NADIA BELERIQUE
BODY
IN TROUBLE

FOGO ISLAND ARTS

Sternberg Press

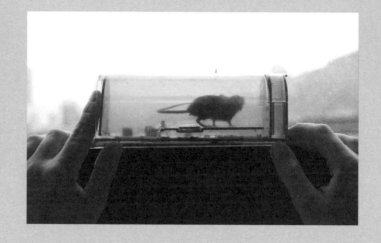

3 CONTENTS

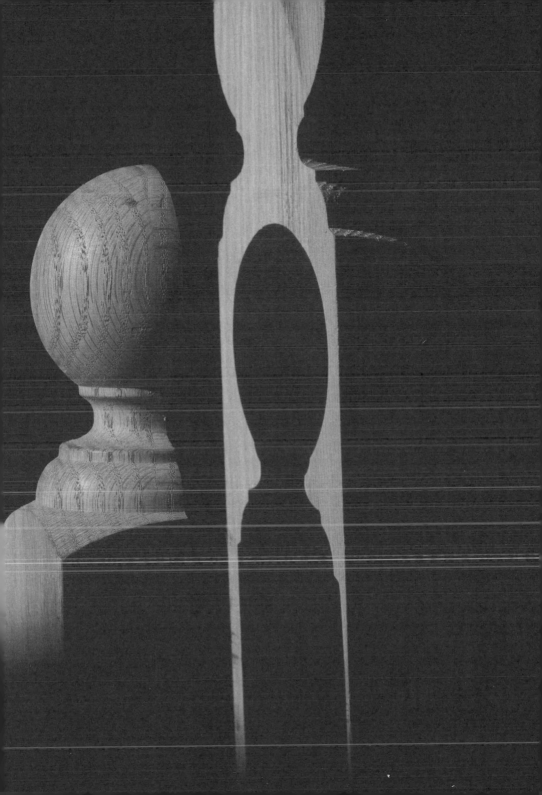

WHO DO YOU TALK TO?

CLAIRE SHEA AND NICOLAUS SCHAFHAUSEN

Oh, just want to push somebody
Your body won't let you
Just want to move somebody
Body won't let you
You want to feel somebody
Body won't let you
Who, who, who do you talk to?
Who do you talk to?
Who do you talk to?
When your body's in trouble
The body's in trouble
The body's in trouble
When your body's in trouble, who?

Excerpt from Mary Margaret O'Hara's "Body's in Trouble", 1988

Following a residency at Fogo Island Arts seven years ago, Nadia Belerique was invited to present a solo exhibition of her work in 2022. "Body in Trouble" is a new series of works by Belerique that are directly linked to her residency at Fogo Island, where she began to experiment with integrating sculptural and architectural gestures into a practice that was predominantly photographic at the time.

Nadia Belerique was born in Toronto, Canada, in the early 1980s, growing up around the time when Canadian singer-songwriter Mary Margaret O'Hara's song "Body's in Trouble"(1980) was released. The song is an important starting point for Belerique's new work, which, like this track, is concerned with the experience of the physical form and its discontents. "Body's in Trouble" has been praised for straddling a tension between tradition and formlessness, a characteristic that Belerique's work also shares. In her work, everyday materials and art historical tropes are networked in ways that develop meaning but also remain open-ended, encouraging the viewer to follow visual clues but also bring their own meaning to bear on the work, all the while fitting into a carefully constructed set of relations.

Working across photography, sculpture, and installation, Belerique's new body of work draws on both sincerity and satire to construct an installation to be entered that is simultaneously an image to be experienced. Working like a film director or set designer, Belerique carefully considers how objects are placed in space to create a scenario that is a scene to be experienced but also offers up a meta-phorical scene for the imagination—as a means of ques-tioning how images are mediated, while also considering how meaning is ascribed to objects.

Belerique's work draws influence from the Pictures Gener-ation, a loose-knit group of American artists who came to prominence in the 1970s and 1980s.[1] In a world that was increasingly mediatized, this generation of artists worked in photography, film, and performance, to explore how images shape our perception of ourselves and the world around us. This was happening at a time when there was disillusionment around the unrealized political and social changes that had been sought in the late 1960s, alongside an increasing understanding of the power of mass media to shape identity. The work was often characterized by portraying recognizable images while playing with their ambiguities.

Coming of age at a time when the power of the mass media was growing infinitely, Belerique's primary access to "culture" was via the television and eventually via the internet, situating her in a world in which everything has felt mediated by screens. This developed her interest in the power of the screen or "frame" to provide meaning and the tension between the two and three dimensions that are contained within.

In Belerique's early photographic work, framing and per-spective are important features. *If I Had Words* (2022) comprises two images that were taken several years ago that are being shown for the first time as part of this exhibition. It demonstrates Belerique's fluency with these

devices. At first, they appear to be somewhat prosaic images of a mouse in a trap. The trap is grasped by the artist as if it were a camera, working to frame the landscape beyond its viewfinder. However, by zooming one's vision out, the images become more complex. Belerique is indeed looking through the viewfinder, but the camera is being held by another person. This scene has been meticulously constructed by Belerique, mediating one image after another through various screens, but all layered into a singular image.

For Belerique, sculpture, installation, and architecture have brought new dimensions to her work, offering the potential for a shift in perspective and a new way of approaching framing, adding more of a spatial dimension to her practice. This approach also enables her to elaborate on material associations, creating scenes that operate like images to be entered. In "Body in Trouble", she brings together *How Long Is Your Winter* (2020–22) and *Everything, All the Time* (2020–22) to create such an experience.

Sincerity and satire coexist in these works, with the objects appropriated by Belerique for their familiarity and, therefore, associations, but also their formal cues. For example, in the case of *How Long Is Your Winter*, an array of blinds of differing lengths, shades, and opacities line the wall. Some feel characteristically domestic, others more corporate; all are associated with the act of concealing and revealing. This simultaneously creates the illusion of a screen that also physically frames the space, thus providing a backdrop to *Everything, All the Time*, a series of posts that act as statues. They have been reframed by Belerique through a set of relations—through their proximity and scale—that make it almost impossible not to think of them as characters in this setting. The groupings create a feeling of intimacy amongst them and evoke, for the viewer, a sense of being a casual observer to a private moment or perhaps even having one's own conversations overheard. They are, at once, oddly familiar but also com-

pletely decontextualized. Several have been treated with
stained glass scenes depicting hands caressing the sur-
face, in a gesture that is intentionally humorous.

Throughout "Body in Trouble", this play with perspective
and framing is omnipresent. The scene has been carefully
crafted by Belerique, and as one's perspective shifts, the
viewer becomes aware of the entire construction and real-
izes that Belerique has trapped them in the image she has
carefully crafted through a set of framing devices, like the
mouse in *If I Had Words*.

1 "The famous last line of Barthes' essay, that
'the birth of the reader must be at the cost of the
death of the author,' was a call to arms for the
loosely knit group of artists working in photog-
raphy, film, video, and performance that would
become known as the 'Pictures' generation, named
for an important exhibition of their work [organized
by Douglas Crimp] that was held at Artist's Space in
New York in 1977." Eklund, Douglas. "The Pictures
Generation." In *Heilbrunn Timeline of Art History*.
New York: The Metropolitan Museum of Art, 2000–.
http://www.metmuseum.org/toah/hd/pcgn/hd_
pcgn.htm (October 2004)

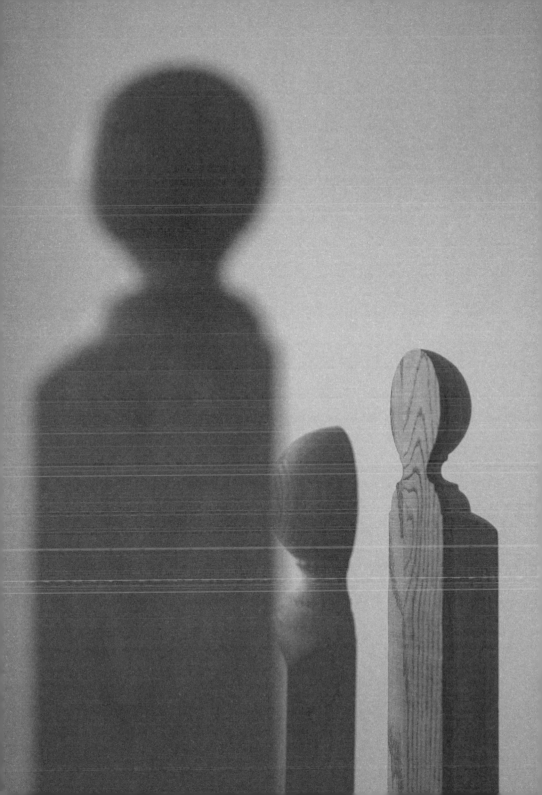

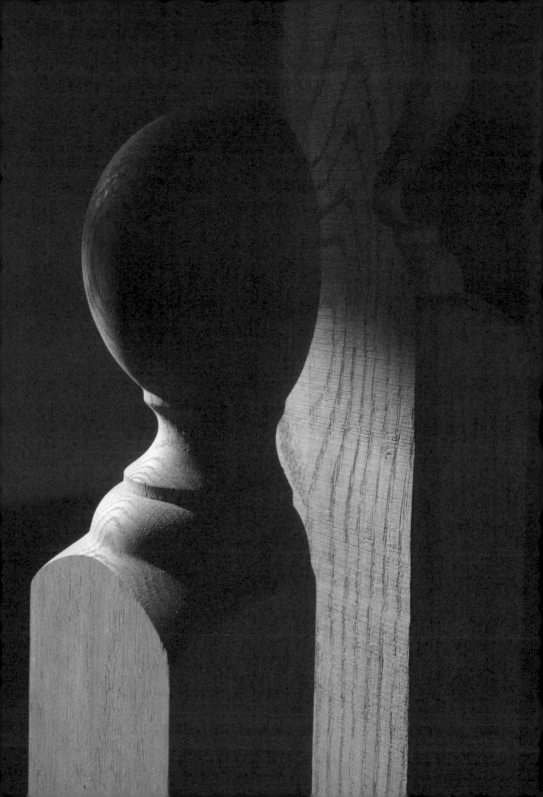

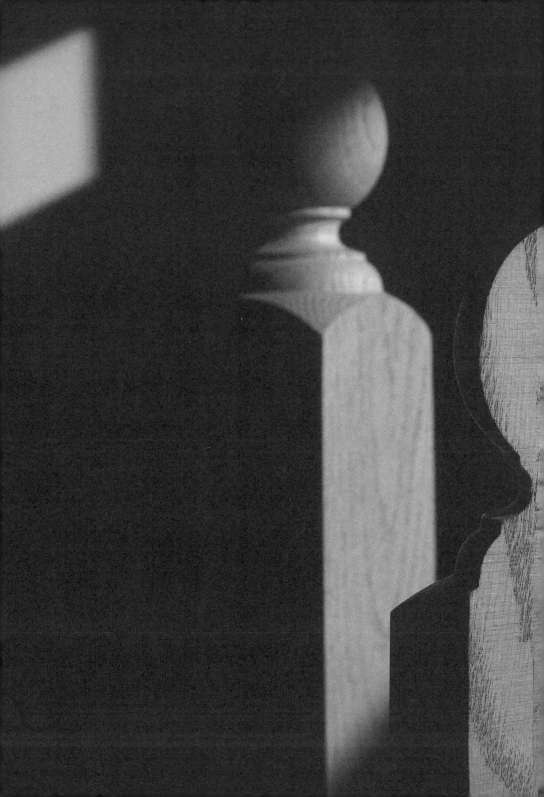

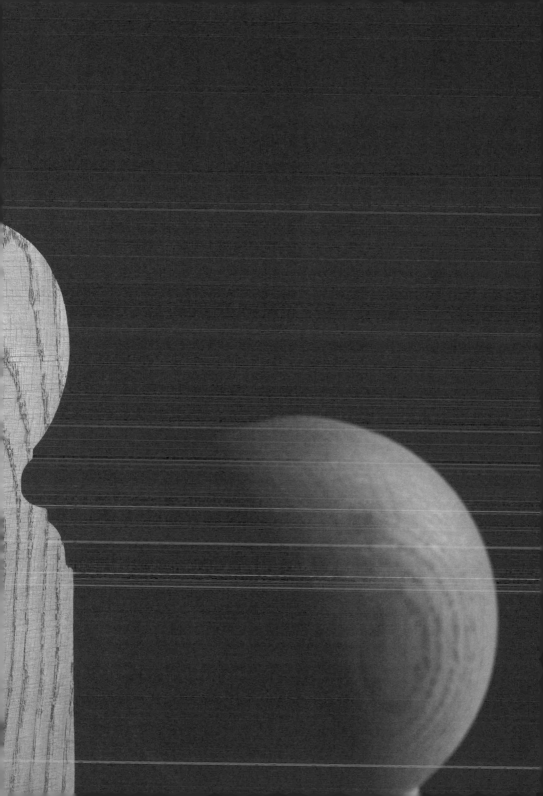

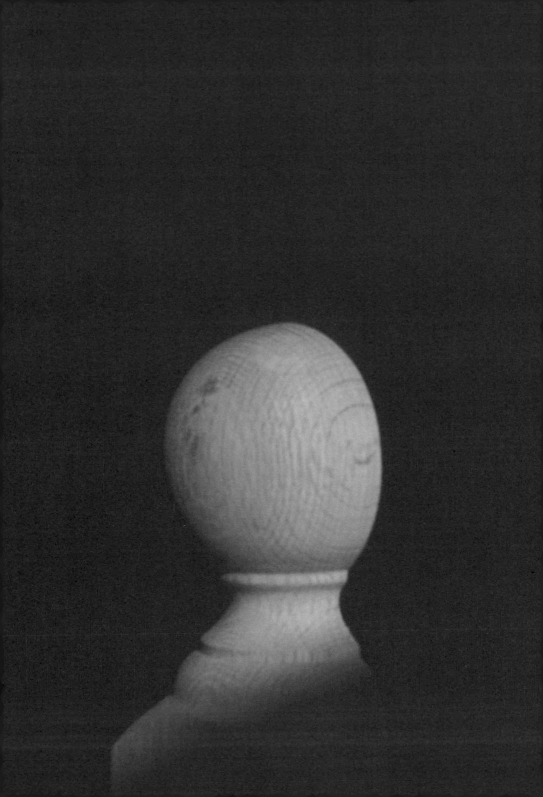

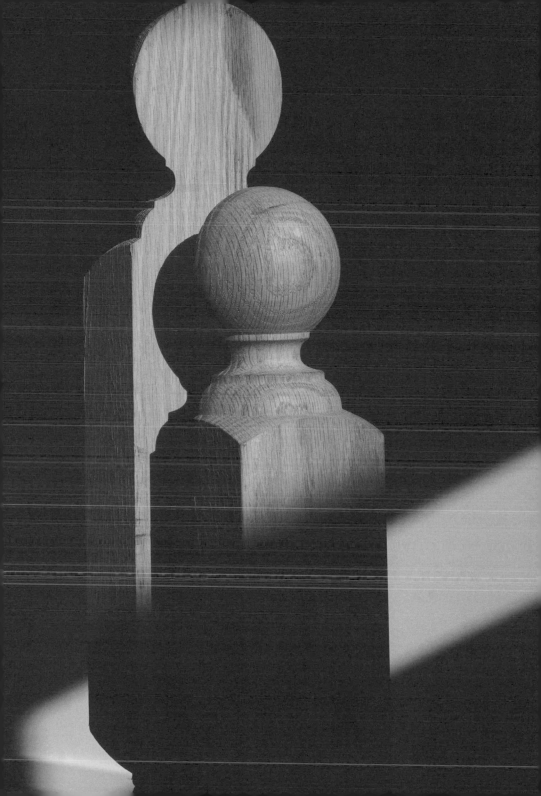

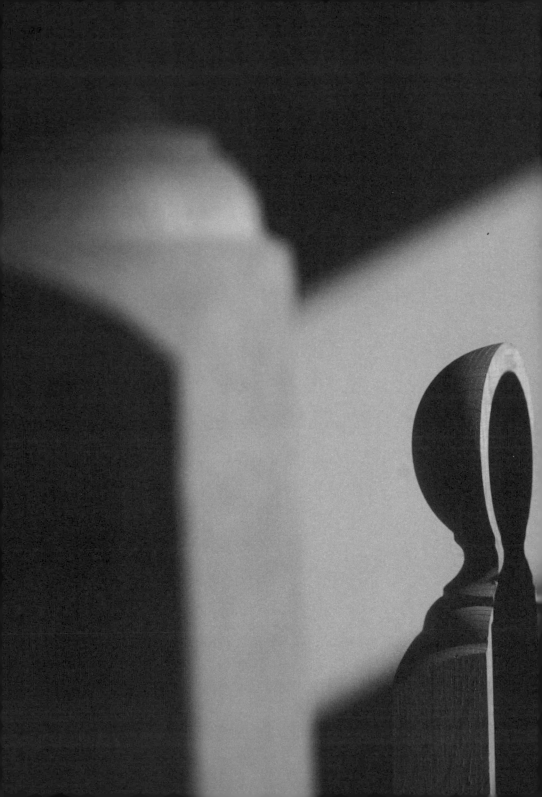

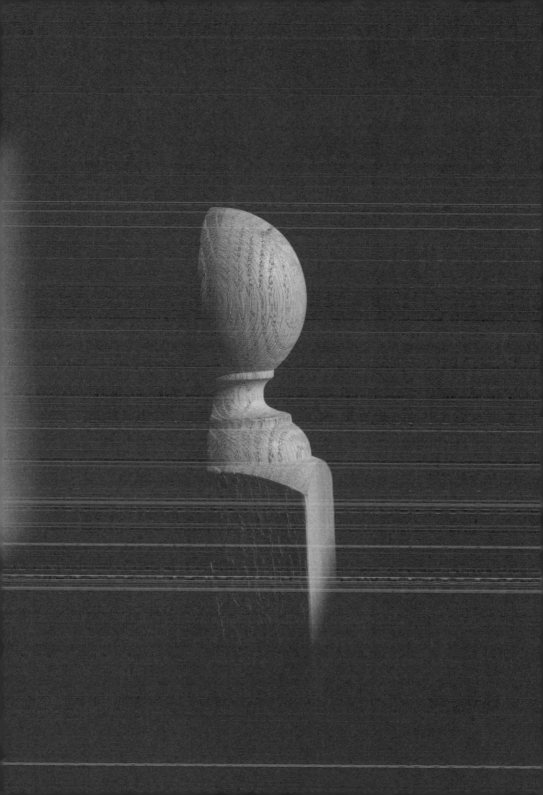

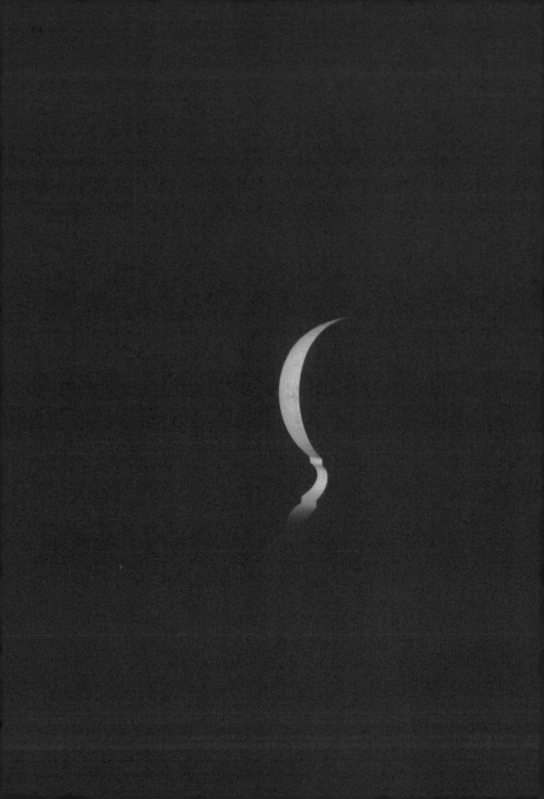

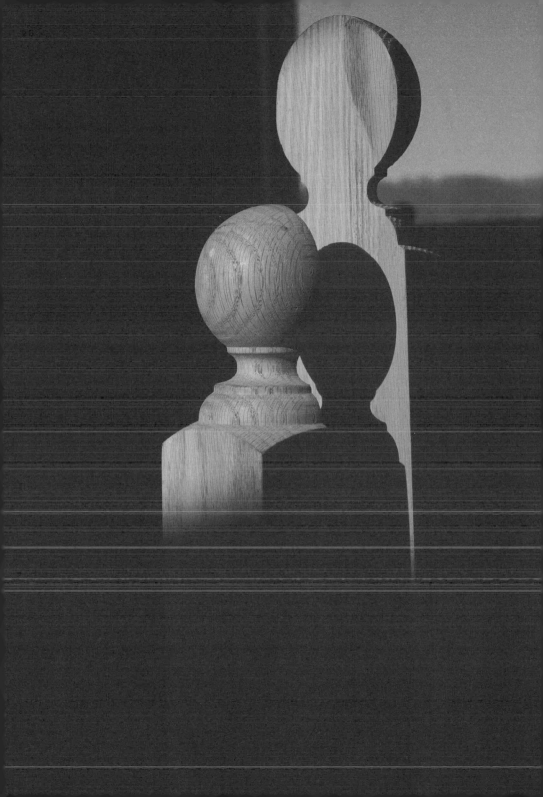

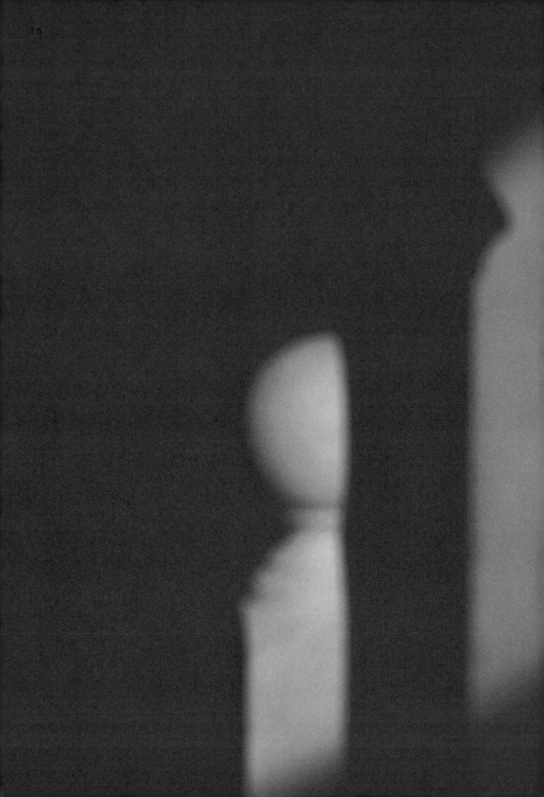

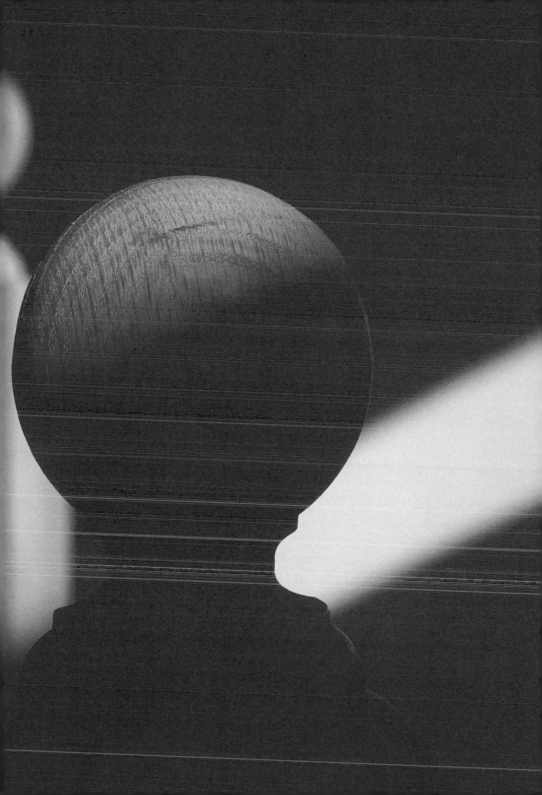

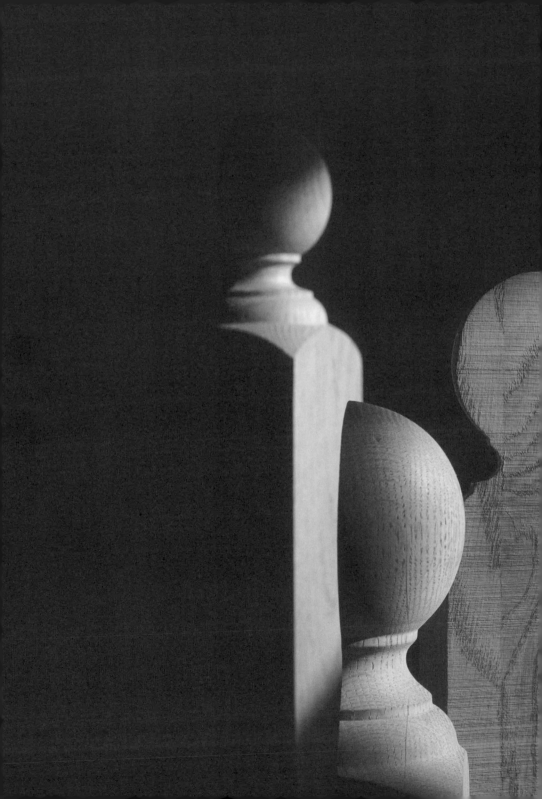

NADIA BELERIQUE: HOLDING THRESHOLDS
RUBA KATRIB

Conjuring a surrealistic noir, Nadia Belerique's work takes elements of interiors and the environment and charges them with pathos, asking what possible narratives can play out as the objects around us become twisted, distort our perceptions, and close in on us. Many of her works and installations feel akin to the depiction of the looming sheets of frost that are slowly closing in on the world of Anna Kavan's novel *Ice*. The enveloping chill creates an urgent setting for a psychologically charged and abstract narrative, with moments of piercing lucidity. The environment and its mood menace the characters, spiralling towards an apocalypse that makes human desires and behaviours both mindless and mad: "The whole world was turning toward death." At the same time, worlds exist within worlds. The *mise-en-abyme* journey of *Ice* resonates with Belerique's work, where the artist explores the tensions that arise between the expansive yet claustrophobic effects that can be produced through repetitions and recursions. A new space opens up but also narrows to an invisible point. These points create quiet moments of implosion, where things start to split apart. Characters leave traces but are largely absent. Light and darkness, movement, the elements, and temperature are evoked. In her story, Kavan does not fully sketch out the world she creates or the characters that populate it—she ensures it remains vivid even as it is unknowable. It is also in this manner that Belerique gives partial glimpses of the worlds that she manifests through her works: it is not so much to reveal, but to obstruct totalities. Originally working in a photographic practice, Belerique imbues her sculptures and installations with image-like qualities. A flatness pervades, which then opens up into space. In a similar manner, her photographs are very much about objects, accentuating their dimensionality and materiality.

Belerique's exhibition "Body in Trouble" at Fogo Island Arts enlists works to create a partial scene. One series included in the exhibition works as a sort of illustrative key to the ideas emerging in the show, where a world within a world is captured in a photographic diptych,

If I Had Words (2022). The photos are of a mouse shut inside a humane trap, an orange translucent tube. The trap is held within the artist's hands and level with the sill of a window, which reveals a bright blurry world outside. In each image, the mouse is lurching in one direction or the other, reaching the limits of its container. In the images, Belerique holds the trap almost like a camera, or at least another lens through which to look out of the window from an interior space. The layering of lenses—between the camera lens that captured the image, the orange plastic, and the glass of the window—creates a sense of distortion, and it is in this manner that the interior and exterior unfold. The boundaries of the trap, the window, the house, and the environment are formed and experienced by the perceptions of the beings that are inside them and butting against their confines. The spatial limitations of the panicked mouse—who transgressed the borders of the house—are put in direct contrast to that of Belerique's environs, as the entity who now holds the object and its inhabitant in her hands. Within the image, this action is also put in contrast to the bigger world outside, which the mouse doesn't perceive even if it can catch a glimpse of its light and shapes coming through the window—all the viewer can make out as well. Is Belerique trying to show the mouse the outside world that he will soon return to, which he ignores for his

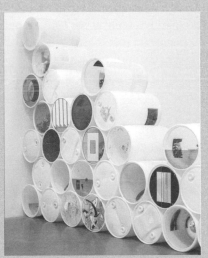

Nadia Belerique
HOLDINGS, 2020–
ongoing (detail).
Plastic barrels, stained glass, lead, copper tape, fabrics, photographs, rainwater, paint, various objects, dimensions variable.
Installation view, "2021 Triennial: Soft Water Hard Stone," at the New Museum, New York.
Image courtesy of the artist and Daniel Faria Gallery, Toronto.
Photo: Daniel Terna.

immediate surroundings? The matryoshka doll effect cre-
ated in the images takes on a dark and even humorous
sensibility. The viewer of the photographs is put in the
same bodily position as the artist—gazing at the mouse—
in a space, looking at another space, that is inside
another space. It isn't just the mouse that is constricted.

This collapse of space and environment in these
photographs sets up Belerique's material investigation
throughout the rest of her exhibition. It also refers to a
recent body of work, which is not included in the exhib-
ition, which offers insights into her process of using
containers, and the very idea of containers, in a more
sculptural form. *HOLDINGS* (2020–ongoing) utilizes
commercially available shipping barrels for the transport
of personal items across the ocean. These objects are
familiar to Belerique as they are what her family used
to send goods back and forth between relatives in the
Azores islands, where Belerique's parents are from, and
Canada, where she was born and raised. As she works
with them, laid on their sides into industrial stacks, they
are modified, staged, and filled with images and objects
like gloves, a shirt, patterned stained glass, a small chair,
dried flowers, and plastic toys. The openings into the
interior spaces in *HOLDINGS* are composed of the circu-
lar tops of the barrels, which turn into an arrangement of
surfaces that produces a collective image. Each of the
barrels comprising the installation is treated differently;
sometimes the top of the barrel is covered with stained
glass or contains articles inside. The unique barrels
come together to create a pattern and composition that
has a kaleidoscopic effect.

Each time that Belerique exhibits *HOLDINGS*, she alters
the interior worlds that the barrels contain as the work
evolves and morphs. Therefore, the work is not static
or overly tied to the exact items and scenes she is cre-
ating for each one, but is more about their movement
and shifts over time. The barrels themselves have been
used and show the wear and tear of transport. By alter-
ing them in each presentation, they can evoke the back

and forth between the sender and receiver that is characteristic of the barrels' intended use. In that sense, a conversation builds. The worlds depicted in them are fixed for a time, but they also have the possibility to go places. They oscillate between being vehicles for images and objects, a space between dimensions that Belerique often straddles. When facing HOLDINGS head on, an image composed of several vignettes is revealed, which then stretches out into the three-dimensionality of the tubular form. In this way, there is an elongation of the image created, emphasizing that the image is a vessel, and vice versa. The notion of the container reappears in the images of the mouse in the tube-shaped trap. This tube is captured from its side, but there is a roundness manifesting as a curved extension to the image, which Belerique expands on in her sculptures.

While HOLDINGS takes up space by physically defining it, the smaller scale of the orange trap is manipulated in Belerique's hands. As she holds it, she creates a composition that speaks to the process of image making by incorporating the artist's hand in staging the scene. Imprints of Belerique's body re-emerge as traces in another series of works titled Everything, All the Time (2020–22), which is placed in conversation with If I Had Words in the exhibition at Fogo Island Arts. In this series, Belerique arranges freestanding wooden staircase balusters upright in the space. Some have been split in half, some stand alone, and some are paired with their other half, while others are matched in a faceoff with differently sized and shaped partners. The upright and isolated balusters with their balls, curves, and indentations start to resemble bodies. The rounded forms at the tops become heads. Standing erect, they evoke Alberto Giacometti's existential bronze human forms. On the flat surface of some of the cut balusters—an interior space that is normally not visible—Belerique has inserted a stained glass pattern that also depicts the outline of her fingers, as if still gripping the object. Thus, her hands have, in a way, stained the wooden objects, leaving marks where she would have held them. However, this moment of

touch is depicted in a material that memorializes the moment of contact between the artist and the work. The decorative glass creates a translucent remnant of the artist's own body on the newly formed bodies of the balusters. In them, roundness meets flatness and image meets object.

The alterations of the balusters in *Everything, All the Time* is fairly direct—a singling out or splitting of a familiar form that creates a new image and possibility for the object. The works create a landscape of verticality, with the balusters at times facing each other like couples or standing alone, single. These ornate objects take on a quiet mood when removed from their intended use in the more functional lineup of the staircase. As a group, they produce a sombre gathering. The stained glass interiors become the incandescent guts of these new bodies, revealing the secrets to their creation—the artist's fingertips present as evidence of their handling. Belerique often plays with ambiguous illusions in her work, where an object or image can be seen in a number of ways. Her approach harkens to the childlike space of imagination and fantasy in the domestic environment, where mundane and everyday objects can come to life. Shapes turn into figures and characters that populate the interior imaginary. Like "the curves of a baluster turns into bodies", the ridges of large-scale steel key sculptures are cut to resemble profiles of faces, as in Belerique's 2018

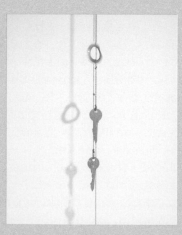

Nadia Belerique
Body Keys, 2018 (detail).
Waterjet cut steel, cahin, glass, pouring medium,
54 x 20 x 1/4 inches (each).
Installation view, *The Weather Channel* at Oakville Galleries, Canada.
Image courtesy of the artist and Daniel Faria Gallery, Toronto.
Photo: Toni Hafkenshied.

works *Body Keys* and *Finger Keys*. In other related works, Belerique depicts doors—removed from their frames and function—and renders them as characters, as portals, and as figures. In a 2019 series of free-standing steel fire doors, Belerique altered them until they became suggestive of portraits, windows, photographic frames, and containers for other objects and materials, not dissimilar to *HOLDINGS*. Connected in their presentation to *Everything, All the Time*, the fire doors stand alone, yet in this series the figures they become are adorned with more individual characteristics, decked with accessories and interventions like stained glass windows, flannel robes, baseball hats, shoes, and lit candles. They transform from front to back, splitting up space and operating as a frame, a figure, an image, and an object. An earlier photographic series, *Doors* (2018), similarly considers the door as a portal between one space and another. The diptych captures a wooden door ajar at different angles—the side of the door dividing the frame into an inside and outside that exists beyond the frame. One of the photographs in the diptych has stickers placed on the inside of the glazing, with only the back of the sticker visible when observing the framed image. This gesture creates a box or a room around the image of the door. Here the glazing no longer just encases the photograph and offers a view onto the image but works as a fourth wall that encloses the space.

The thresholds that separate inside and out are central to Belerique's exhibition. Its title, "Body in Trouble", speaks to the anxiety of the flimsy lines and membranes that hold us and the world together, while also creating separations. The split balusters in *Everything, All the Time* become severed bodies, some of which are then finished with stained glass interiors that make them whole again. An additional third work included in the exhibition, put in relation to *Everything, All the Time* and *If I Had Words*, is *How Long Is Your Winter* (2020–22). This work is composed of an arrangement of neutral-coloured blinds (beige, grey, off-white) lining and forming the interior walls of the space. This is an ongoing

work in which the blinds are placed against the archi-
tectural perimeters of a room. The blinds either are
blocking out or letting in slivers of natural light or, as in
this case, are artificially lit to mimic the light they are
meant to block out. In essence, they cover windows,
real or constructed. The blinds let in more or less light
and transform the qualities of the environment. Lining
the space where *Everything, All the Time* is installed,
they create a play of light and shadow, while movement
and stillness emerge. The blinds create thin and porous
edges between a here and there that is alluded to in the
exhibition. The pairing of *Everything, All the Time* and
How Long Is Your Winter further pushes the experience
of the balusters as interior entities in their own domes-
tic space. The verticality of both works is emphasized,
and while the balusters are completely still, the blinds
and the light change around them as the blinds rotate
open and closed, suggesting the passing cycles of the
day. This notion of time is offered in the title *How Long
Is Your Winter*, a question that provokes a locality and
an environment through a period of shorter days, longer
nights, and increased darkness and cold. The enclosures
of space that Belerique evokes through the exhibition
take on associations with a particular season, forms of
hibernation and domestic interlude, and a world that
closes in and limits movement. As the blinds form a
permeable layer between the interior and exterior, they
block out any concrete view of the outside and only let
in rays of light. Through their opaqueness, they evoke
the image of the mouse in his trap that is located in an
adjacent room. In Belerique's works, the external world
often appears as a blur, at most reduced to the shapes
and light visible in the window of *If I Had Words*. In this
way, the suggestions of the external world start to form
an ellipsis, referring to a reality that extends out from
what is actually visible in the works themselves.

At the end of Kavan's slippery novel, a man and woman
are in a car racing against the inevitable encroach-
ment of the frozen world. Driving with the heat on, they
can momentarily hold the ice at bay. As the narrator

describes: "As fast as the frost-flowers were cleared from the windscreen they reformed in more opaque patterns, until I could see nothing through them but the falling snow; an infinity of snowflakes like ghastly birds, incessantly swooping past from nowhere to nowhere." This physical and aesthetic collision and collapse between the interior and exterior resonates within Belerique's works. The presumed security of the interior is put under question, by underlining the edges between what needs to be held inside and what needs to be kept out and exploring the elements that transgress boundaries, like light. She explores these limits through each stage of enclosure that she creates by stacking, building, layering, and framing to make a world within a world—yet at each level she pokes a hole or undermines the sanctity of the perimeters. The fire doors she uses to turn into sculptural altars of sorts are removed from their intended function of keeping a dangerous element at bay and securing an interior. The closed plastic containers of *HOLDINGS* are meant to keep things separate from one another, secure, and dry for sea freight journeys—yet Belerique pokes holes in them, turns them into windows and stages, and redefines them as psychic spaces that have become porous. In *If I Had Words*, an oblivious intruder oversteps the limit between inside and outside. *How Long Is Your Winter* speaks to the control of light and visuality from an interior space, a way of blocking out and keeping at a distance what is just outside. The enclosing of architectural spaces extends into the works themselves. Belerique continues the strategy into even the traditional devices of enclosing artworks, such as placing the stickers highlighting the glazing, and thus the boxes of the frames, in the photographic diptych *Doors*. These playful manoeuvres coalesce into a body of work that turns the elements and objects that make up the worlds that Belerique creates into other images and things—they start to appear differently, alive even, with inherent characteristics to be amplified. Belerique underscores the charged aspects of the elements and things that surround us, animating her objects and their interior worlds.

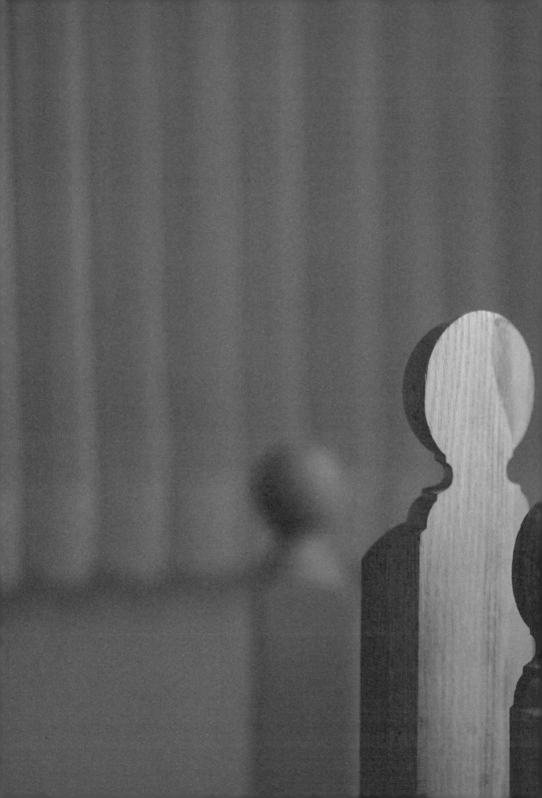

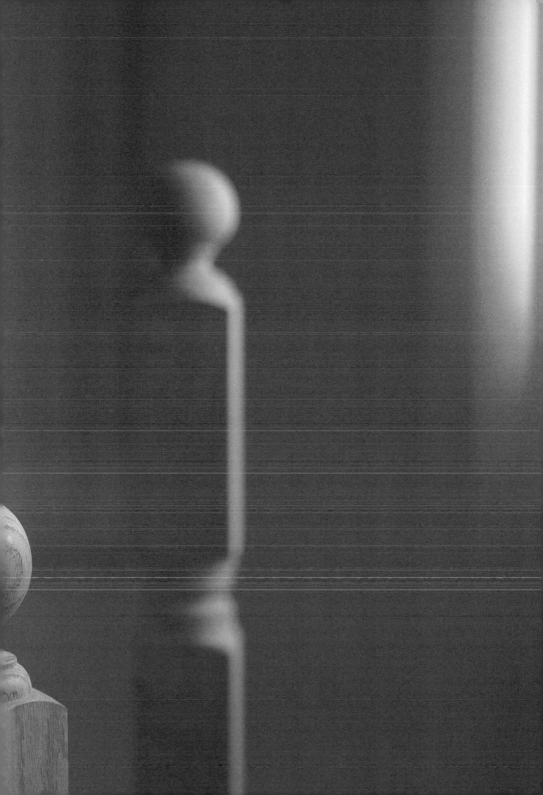

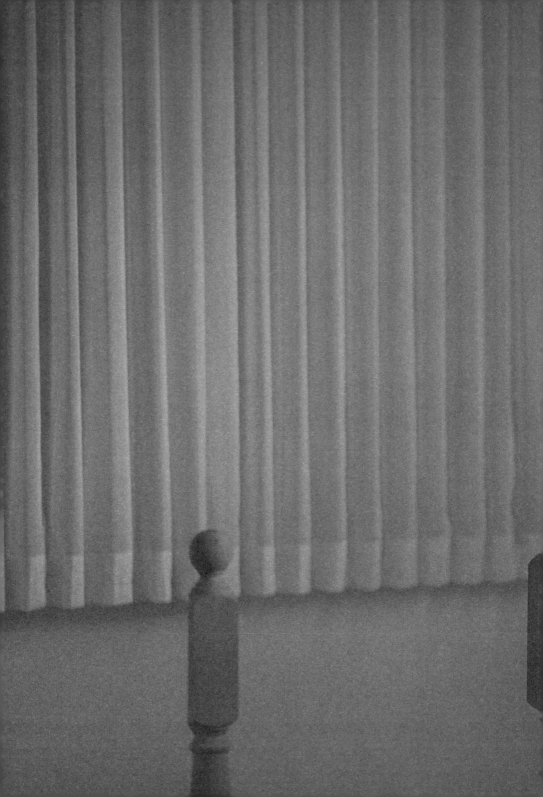

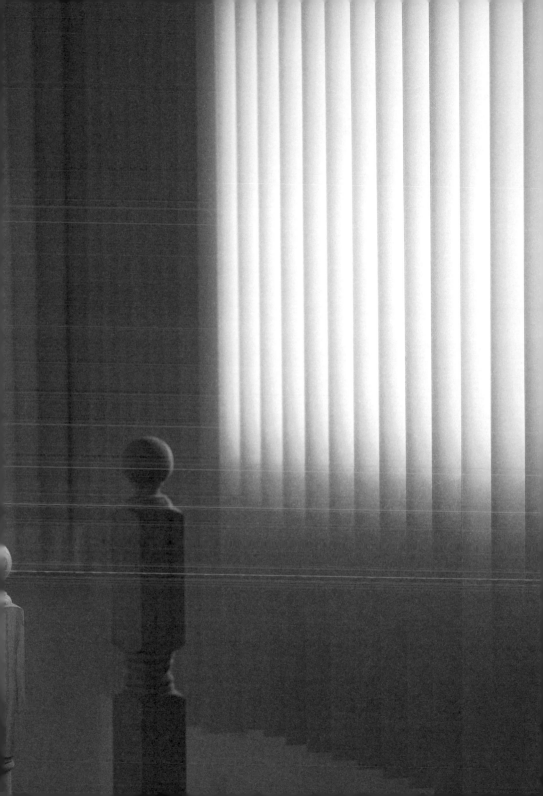

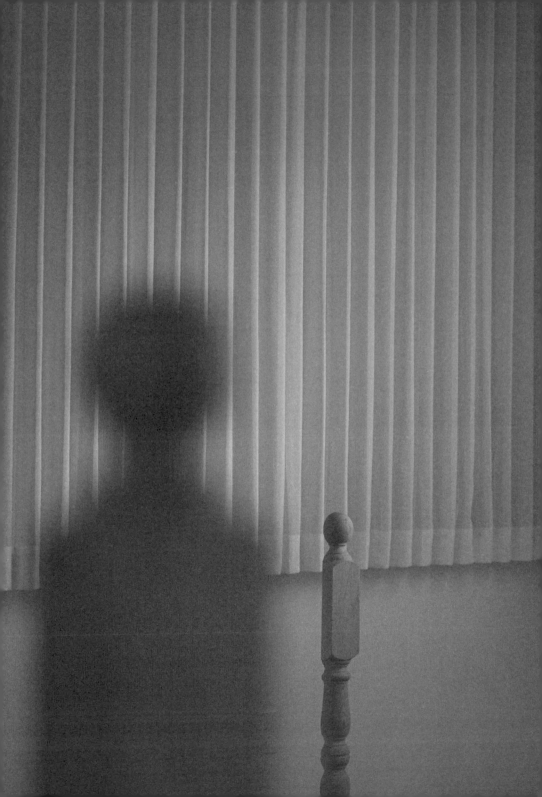

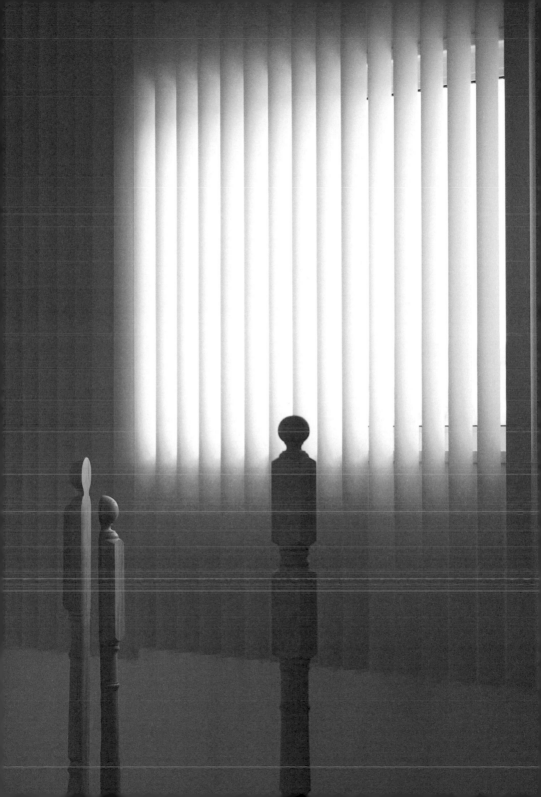

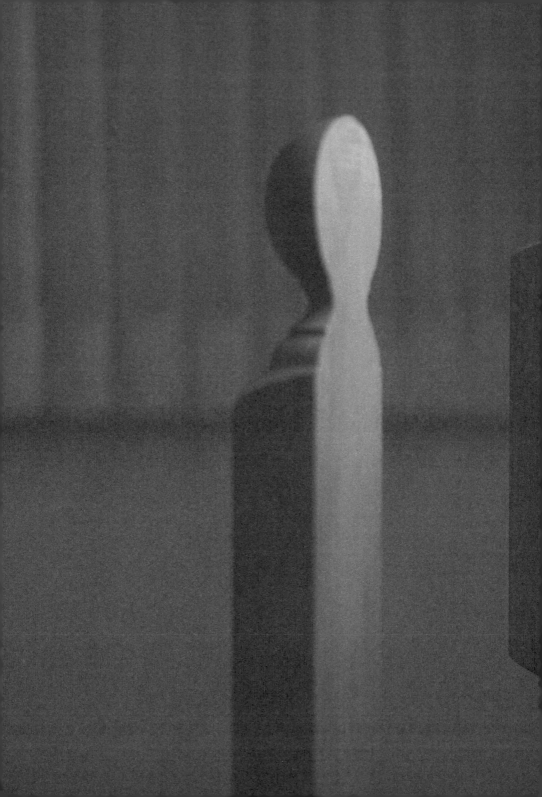

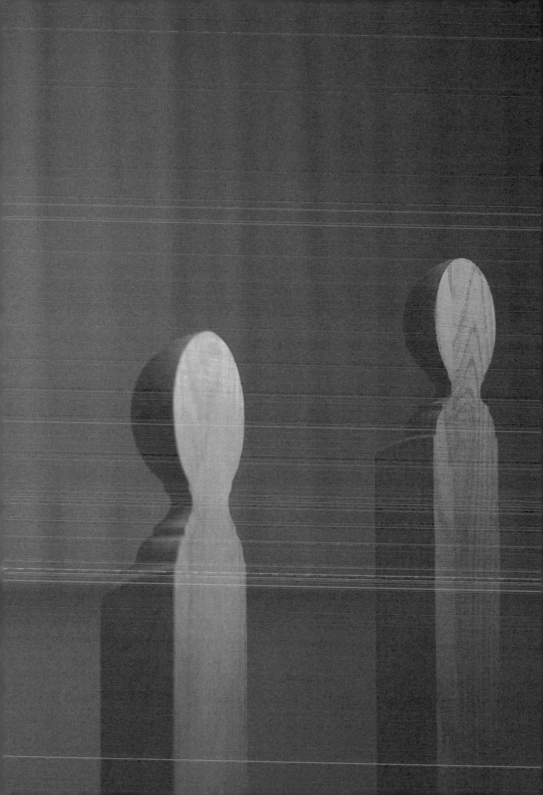

IF I HAD WORDS
NADIA BELERIQUE IN CONVERSATION WITH CLAIRE SHEA

CLAIRE SHEA
Let's start with discussing your practice overall and where it comes from.

NADIA BELERIQUE
One way to contextualize my work, or at least an illustrative person that I reference, is Louise Lawler, just because there is something sort of indirect about the way that she uses photographs and there's something weirdly performative about her practice. As much as I don't think that my work completely engages in performance in that way, there is something about my experience as an artist that feels like there is a constant quasi self-referential thing going on. So, as much as there is an apparent sincerity to the work—because there is—there is simultaneously satire involved. I think that a lot of the formal cues take the form of art objects: for example, the posts in this exhibition that operate almost like statues. Maybe that's where my humour comes from, as there is this reference to art itself oftentimes in the work. I think when I look at Louise Lawler's work, there is something that I can relate to in this subtle, very unobvious way which I find to be a fun and interesting way of approaching art. And I feel it's like a feminist sensibility. I feel like it's this performance, even at times of quoting an art historical canon, that enables me to use these kinds of modes that make sense, let me use these inventions. Basically, I'm constantly trying to reveal that in all art, media, politics, film, there is always a strategy at play. There's always language underneath.

CS
Where did this interest develop?

NB
I grew up quite sheltered from any kind of real exposure to art. Most of my exposure to any western "cultural world" was just television, and very specifically television as a media form. Barely even internet, and the internet didn't even interest me until Tumblr, basically. I think film was my first foray into thinking about art. And also, I was

just really into drawing as a kid. There was something about art that interested me; I wanted to do art. I feel like contemporary art is like film maybe, and I often find that I feel like I think more like a filmmaker.

CS
I think what is interesting about the way you work is that you seem to imagine a set or, or a set of things coming together, similarly to a director or filmmaker.

NB
I think it's hard for me not to come at it from an image-based, cinematic kind of way. I think this has totally mediated how I spent most of my time, even though in my adult life, seeing things in person changes everything. I want my art to be experienced in person because it turns out that's the best. When I'm back alone in my studio, I'm always just thinking of things mediated through a screen, so I think that's why there is this image-based beginning to all my work.

As soon as I had a studio, a dedicated space to actually treat things, images became objects as soon as they entered the studio. As soon as they became objects, things started to change and shift and immediately they become placeholders for other things and all of a sudden it's a set and all of the images and objects are just extras. And it's just this whole scripted, make-believe kind of thing. That's just a feeling for the most part that makes sense.

I was going from taking photos in this real documentarian sort of way at first, for example, Nan Goldin was my favorite reference point, and particularly the postmodern female perspective. And then this other side of me, maybe even in training too, found the work of Christopher Williams compelling because it was looking at the apparatus of photography, the fabrication of it.

I found that the dichotomy of looking at things in this real in-the-moment kind of way, along with looking at it

from the outside, was this real mindfuck. I think that was when I realized that this is actually the space I want to make work in, this in-between space. So, not entirely in this cold, kind of analytical sort of sense, but also not in complete denial of what we're operating in and just completely being all feelings and nothing else.

I think that that is where I try to make work, in this moment in between those two places or with this idea that you're constantly bouncing back and forth, almost like an atom in this world of constantly trying to be present and feeling things in sort of a profound way, but then also being completely suspicious of that feeling and trying to understand why that's happening in this psychological way.

It's like constantly being in and out of a moment.

CS
I think that is where a lot of tension in the work comes in, and also the humour. You seem to be stepping in and stepping out, being the author and the actor simultaneously.

NB
Yeah, and maybe that's the performative part. There is this amazing interview about Louise Lawler's work, where Andrea Fraser was basically saying that Lawler is acting like an artist. Not that she is one, but that she's just acting like one. And for me, it's like, *What's the difference?*

I think, in general, that is how I feel about a lot of things. How this sort of feeling of being in the world can be sometimes so hard to pin down—is the art acting like the thing? Or is it the thing? That is also why I find it so interesting to go back and forth between sculpture and photography, because they both have these inherent qualities. They're playing with your expectations about what they're supposed to be. That's where the humour is,

maybe, too, it's just this, it's not cynical.

So, for me there is a suspicion that is constantly there. It's about awareness.

CS
So, it's about languishing in that undefinable space.

NB
Yes. And not in a way that's—and I really want it to be clear—it's not for lack of not being definitive. It's actually because I do know that knowledge, history, is so slippery.

If you're the one creating these definitions, you have to look at the systems that are making these orders and these hierarchies. All of this, like all of the systems of the world, they have to be constantly re-examined, right?

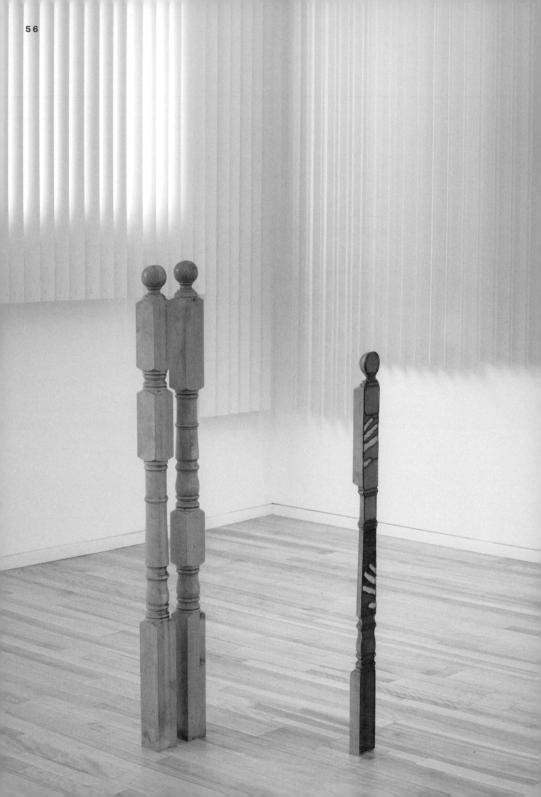

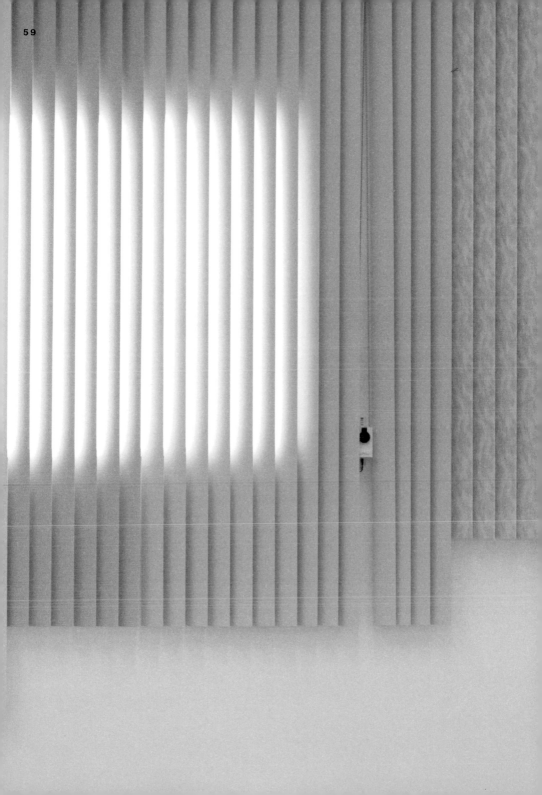

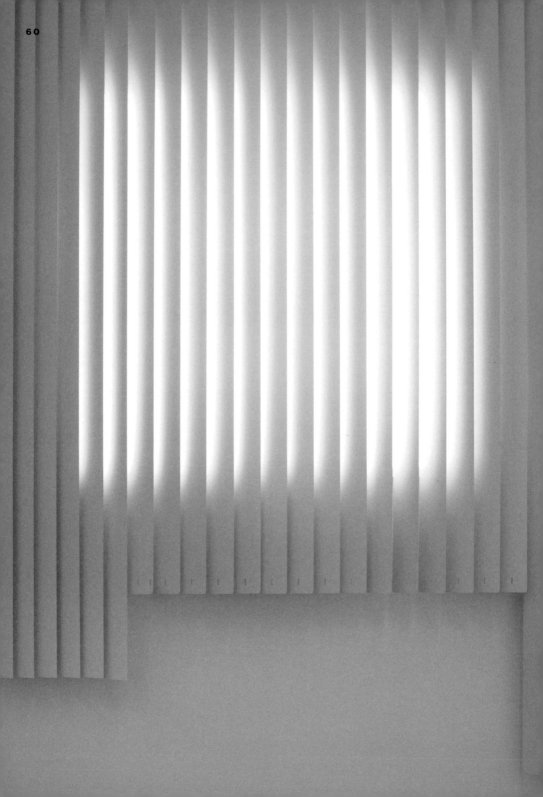

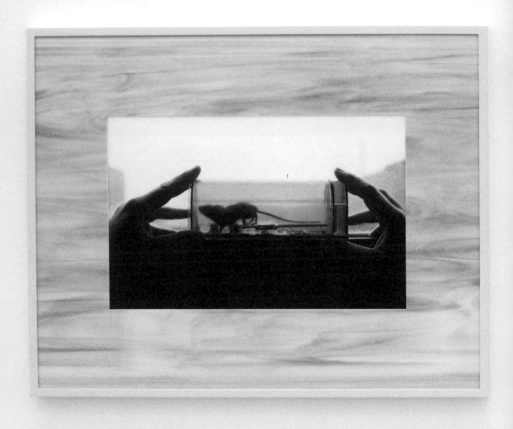

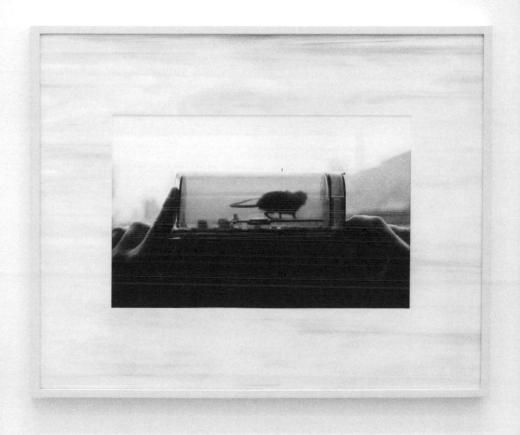

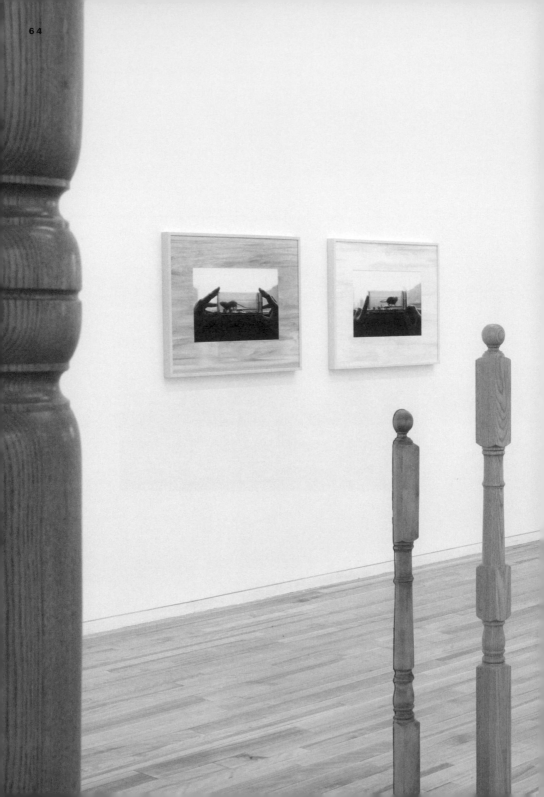

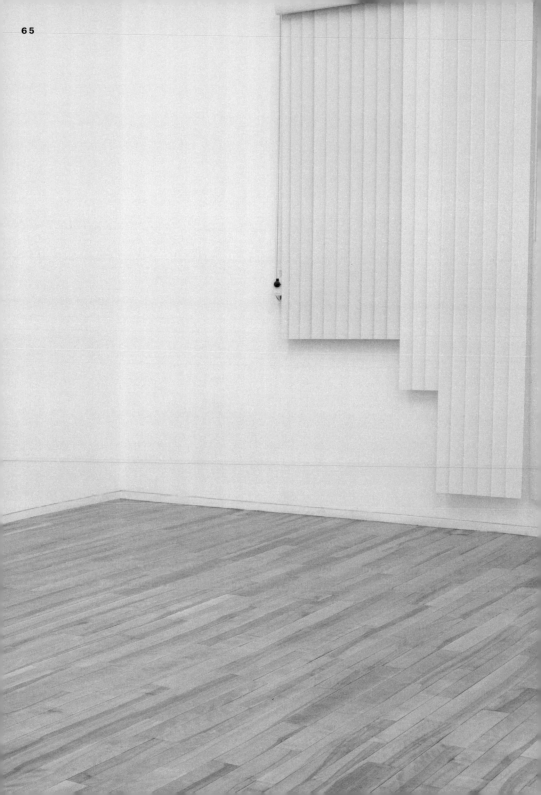

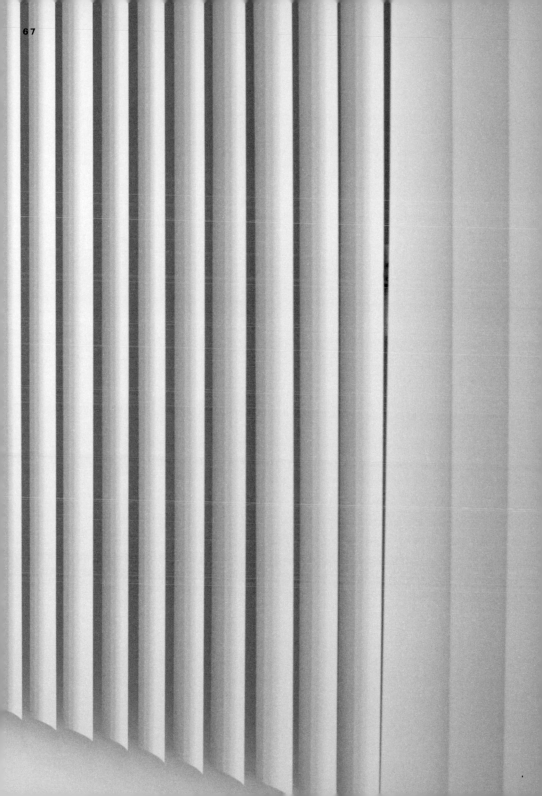

IN AN ABSENCE, WHICH IS NOT: ON "BODY IN TROUBLE" BY NADIA BELERIQUE

TOM ENGELS

#1

"Design always presents itself as serving the human but its real ambition is to redesign the human."
Beatriz Colomina & Mark Wigley, *Are We Human?*
Notes on an Archaeology of Design, 2016.

"Body in Trouble" is an exhibition by Nadia Belerique which gathers three bodies of work that examine the relationship between the body, its domestic environment, and the reciprocal (visual) binds they produce. Unfolding as a series of sculptures (*Everything, All the Time* and *How Long Is Your Winter*) and a photographic diptych (*If I Had Words*), each of the works proposes a particular reading of how body and mind are sculpted by the seemingly banal and harmless presence of mundane architectural elements and furnishings. Belerique meticulously analyzes the ways the environments that are shaped by use equally shape us back in return. She formulates agency as an enmeshment of cohabiting forces; of a shared patterning of time that creates imprints, marks, and moments of opacity and translucency. Trained as a photographer, Belerique heightens the awareness of that which captures—not just the capturing of an image, but of the arresting and haunting forces of the apparatuses we construct and attempt to call home. Capture, drawing from the photographic register as much as the psychodynamic mechanisms domesticity entails, becomes both tool and logic. All of this, in an absence of bodies. In an absence, which is not.

#2

"We don't think enough about staircases. Nothing was more beautiful in old houses than the staircases. Nothing is uglier, colder, more hostile, meaner, in today's apartment buildings. We should learn to live more on staircases. But how?"
Georges Perec, *Species of Spaces*, 1974

A post, a door, a curtain. They appear in the infrastructural mundanity of the everyday. They are there and everywhere. They are grasped and touched upon, moved or opened. They are held in the moment of instability and serve as placeholders for moments of transition—the passing through of bodies, of light, or a nude descending. In the instance of touch, presence, or action, they create a moment of support and permission while activated in their fundamental properties. They are built for a purpose, and in their purposefulness, they exert generosity, a moment of support, for everything that passes over and through them. They become holders of time and space, made for the presence of bodies they couldn't afford. Yet, the post keeps on standing, the door remains ready to pivot, the curtain waiting to be opened.

In Belerique's *Everything, All the Time* (2020–22), staircase posts or newels stand scattered in space. Usually, such vertical structures connect a staircase to a railing system. They are the joint between that which carries and that which protects one from falling. In their normative domestic presence, they are symmetrically composed figures, equally balanced on four sides. They are reliable figures to which one attributes infallible trust; they hold structure while pronouncing the beginning, a joint, or the ending of ascending or descending towards another floor, another architectural stratum. In *Everything, All the Time*, these architectural elements are multiplied, then dissected and spliced. Their inside revealed, a landscape of expressive nerves and texture appears. Testament to their life trajectory—the conglomeration of carbon, hydrogen, and oxygen—these lines are expressive of inert behaviour. They are expressive of what is going on inside, and they constitute a character. Because in the depth of the post resides a character. Materially expressive and functionally generous, such character lends us the opportunity for a depth psychology for furnishing. To understand the domestic arrangement of elements, which we shape and which are shaping us in return. In an absence, which is not.

#3

"... partly because of the fluorescent orange tulips around the birches / partly because of the secrecy our smiles take on before people and statuary / it is hard to believe when I'm with you that there can be anything as still / as solemn as unpleasantly definitive as statuary when right in front of it..."

Frank O'Hara, *Having a Coke with You*, 1960

A house holds character, and character is always plural. *Everything, All the Time* lingers around like an assembly of solemn, solitary figures. Some of them appear as single units; others stand in the company of their kin. In an instance of anthropomorphism, one could distinguish a collection of heads and feet, the contours of a body, as they become a people, a post people of sorts. A house is to be filled with life, and life could be defined as movement—of objects in time and space, a piercing of choreographic vectors. As such, they are undone of their structural function; they were moved (or did they move themselves?) and started to populate and inhabit space. If *Everything* meets *All the Time*, then things are lifted out of an instance of time and brought into permanence. A singular unit of time is transformed into a permanent understanding of time; the one that stays, permeates and endures. It is the moment when the chronopolitical dimension of photography becomes sculptural. It is the moment when one post becomes many, as if all of them were three-dimensional materializations of a series of photographs made in Burst Mode, a camera function that allows you to capture a series of photographs in quick succession. One post having hopped from one place to the other, then been captured. Movement and capture. Movement and capture. Movement and capture accumulated as if time was made frame by frame. Are we looking at a picture produced by a camera? Are we looking at something that once contained movement? Are we looking at the materialization of movement in time? Or is there movement all the time? Everything, all the time. In an absence, which is not.

4

The history of photography is a history of shattered glass.
Teju Cole, *The History of Photography Is a History of Shattered Glass*, 2017

Some of the flat interiors of the posts are covered with stained glass. Lines of lead indicate the lines created by the three-dimensional relief of its opposite side. Between them, glass in hues of dark yellow, orange, and brown create an illogical patterning of color, almost like excerpts of what belongs to the gradient of colors in kin—from dark and varnished to sun-bleached weathered wood. As such, they not only belong to the same palette but also reveal a patterning of time within them. Over time, and through exposure, treated wood slides from one hue to the other, transforming slowly as sun rays pierce through the slits of a curtain, or via the door that leads into the city, via the glass that lets through. In the ambiguous and singular merging of solid wood (that which one believes to be static) and translucent glass (that which one believes to be permeable), a peculiar suggestion emerges that those qualities constitute one another and coinhabit life through a double bind; solidity transforms over time, translucency creates an instance of capture. They hold each other.

On the stained glass, fingers appear. Fingers that touch, brush, or hold. Not a full hand, including the palm, but just each of the five slender jointed parts attached to either hand through which one reaches out to something else, just each one of the five slender jointed parts through which one articulates gesture. They linger on the post as a reminder of their use and the many hands that usually run over them in the daily passing and mundane repetition through which, ultimately, the wood changes shape and the post changes form. The gentleness of a simple stroke carries in its endless repetition the potentiality to alter and animate another body and its condition. And yet again, the fingers are there where the body isn't. In an absence, which is not.

"It is through photography that we first discover the exist-

ence of [the] optical unconscious, just as we discover the instinctual unconscious through psychoanalysis."
Janet Malcolm quoted by Moyra Davey,
Notes on Photography & Accident, 2007

The post people are surrounded by a series of blinds. An accumulation of cream and grey horizontal stripes of fabric, they are reminiscent of the kinds used in office spaces, public institutions, doctors' practices—those spaces that in their sterility try to exert power over the body by way of the regimens of labor, analysis, productivity, and remediation. As bodies aggregate and transform, the blinds form a mediating backdrop as light now and then pierces through the slits, as their individual pieces occasionally flutter in the wind. They are the companions and co-creators of the sterile dimensions of daily life. In *How Long Is Your Winter* (2020–22), the blinds are counterintuitively placed against the wall and removed from their function. As there is no outside, there is nothing to let through or to block out. In a previous iteration of this series in 2021, the blinds were motorized; they moved not by way of human hands opening or closing them, or a gust of wind causing disarray. They moved by themselves. Now, a light box projects artificial light through them. With variables in aperture, the blinds are patterned by way of position and provenance. They envelop sequences of the same slice of fabric reproduced, repeated, sequenced, and serialized, but each with a slightly different, singular position. Then again, they come in different shades and tonalities, suggesting that the blinds are sourced from different rooms, offices, practices, and are gathered here all together. Again, *Everything* meets *All the Time*, and movement, and thus transformation, of the seemingly same object is suggested.

A photograph is constituted by light piercing through the sequential opening and closing of a shutter. Operated by choice, a button is pushed, a shutter opens and closes, and light falls on a light-sensitive substance. *How Long Is Your Winter* articulates this double bind between light, imprint, and sensitive matter. Stemming from a

situational experience of Belerique herself, the blinds were the only thing to look at during long and repetitive sessions of psychoanalysis. One could consider the instance of psychoanalysis as a process, a sequence, or a serialization of moments in which one looks at one's mental collection of imagery that constitutes character. It is the attempt to create an understanding of the patterning of the self through the accumulation of imprints of people, objects, situations, interactions, and utterances on the brain, which is a retina too. The image in the background—the fluttering of blinds—became for Belerique a primal scenery for the recollection of the images of one's own and others. Here, she reverses that situation and articulates the banality of the curtain lurking in the corner as the main image which is recollected as the moment of recollection itself. What is remembered, what left an imprint, is the seemingly harmful presence of furnishing. In the moment of analyzing imprint, trauma, experience—instances of mental photography—the memory that is constituted of that very moment is materialized as the blinds. Uncannily, the blinds resemble the functionality of a camera itself: the flaps of the blinds open and close, like a shutter. They let light pass through them now and then, and permit rays to fall upon sensitive people and objects, unwanted, like a camera controlled by the wind. Through *How Long Is Your Winter*'s blinds, a photo light box emits simulated daylight. A scenographic simulation created for exposure, for light falling onto sensitive substance. In an absence, which is not.

"My house / Is out of the ordinary / That's right / Don't

*wanna hurt nobody / Some things sure can sweep me off
my feet / Burning down the house / No visible means of
support / And you have not seen nothin' yet / Everything's
stuck together / And I don't know what you expect / Star-
ing into the TV set / Fightin' fire with fire, ah"*
Talking Heads, "Burning Down the House", 1982

The two photographs that make up *If I Had Words* (2022)
depict the hands of the artist holding a tube-shaped
mousetrap against a windowpane. In the foreground, a
mouse contained in the trap peeks through the semi-
opaque orange-brownish surface. In the background,
blueish tones produce a blurred image of what lies
beyond the glass that constitutes the window. The photo-
graphs themselves are each surrounded by a pane of
stained glass: one reproducing the color range prod-
uced by the image in focus (skin, trap, window frame,
mouse), the other approximating the color scheme that
establishes the backdrop (sky, clouds, blurred exterior
elements). Just like the photograph, the trap and mouse
come in two, as a double. One would presume to be look-
ing at two shots of the same mouse in the same house,
but as for Belerique, *Everything* meets *All the Time*; one
could speculate that one looks at a different mouse in a
different house. Placed next to each other, in close prox-
imity, the mice look at or away from each other, or at or
away from itself. The mice, spliced and mirrored in time,
look at each other, or at themselves, at another and as an
other—a prototypical condition of (inner) domesticity. If
they had words, what would they say?

The mouse has found a room of one's own in captivity.
The trap is one of the kinder ones—not one that operates
by way of poison, piercing, or smashing, but one of pro-
longed life in the confines of a new home. The little house
has a windowpane, just like the bigger house that it is sur-
rounded by has one, too. The walls of the trap are both
filter and frame through which mouse and human see
the world, and through the world they apprehend them-
selves. For the subject's hands that hold the trap, too, the
trap acts as if it were a framing device, a camera maybe,

through which she looks outside. The mouse in its house, which is a trap, looks outside through the window, which is part of the house of the hands that hold the trap, as the eyes that belong to the hands look through the trap, outside. As to look outside and to see the world, and through the world oneself, means to filter and to frame. There is no capture of that which lies beyond and inside oneself without difference, alteration, and change. As the containment of the body constructs a field of vision, an ocular and mental horizon. As speculum ("an instrument for rendering a body part accessible to observation") and speculate ("to view mentally, contemplate, and to pursue truth by conjecture or thinking") etymologically live side by side in the loopy binds of seeing—that which is captured by the eye and the I. Here, domestic life always seems to be surrounded by broader encompassing strata of domesticity as home, being at home, or being made to feel at home is always a process of violence, of domestication: to bring or keep things under control or cultivation and to accustom them to home life. In this instance, home is always already a trap. The human thinks it caught the mouse, the mouse might think it found a new home, and the house aspires to control the human. The perverted innocence of domestic innuendo. In an absence, which is not.

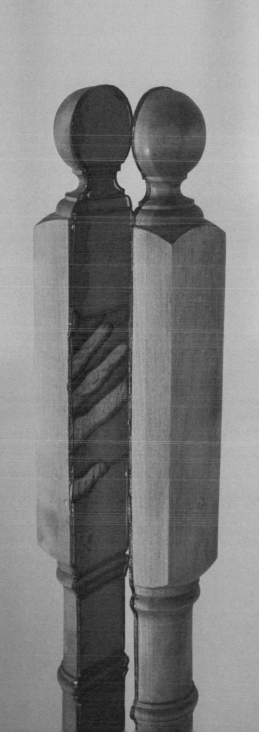

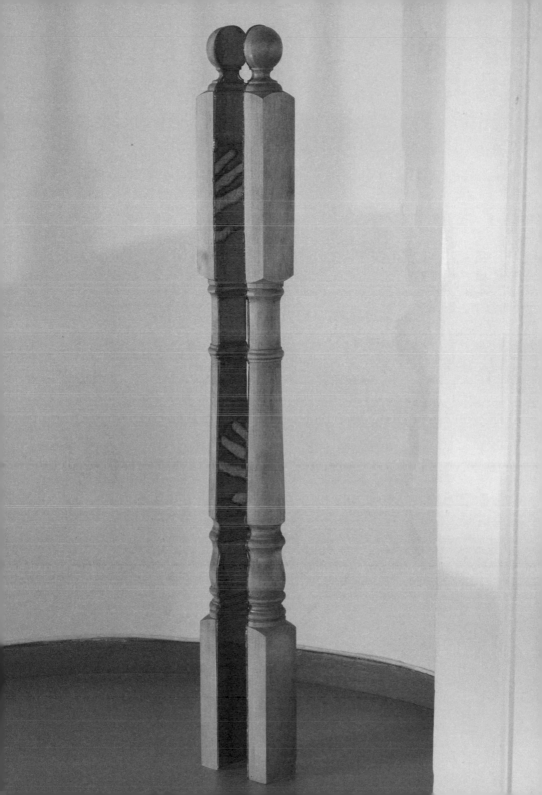

CONTRIBUTORS
NADIA BELERIQUE,
TOM ENGELS,
RUBA KATRIB,
NICOLAUS
SCHAFHAUSEN,
CLAIRE SHEA

Nadia Belerique received her MFA from the University of Guelph. Most recently, her work was included in the Toronto Biennial of Art (2022), curated by Candice Hopkins, Tairone Bastien, and Katie Lawson, and the New Museum Triennial (2021), curated by Margot Norton and Jamillah James. Recent solo exhibitions include: "There's A Hole In The Bucket" at Daniel Faria Gallery (2019), "On Sleep Stones" at Grazer Kunstverein (2018), and "The Weather Channel" at Oakville Galleries (2018). Her work has been exhibited internationally at venues such as Kunstverein Braunschweig, Braunschweig (2020); Lyles & King, New York (2019); Arsenal Contemporary, New York (2018); Vie d'ange, Montréal (2017); Tensta Konsthall, Spånga (2016); The Power Plant, Toronto (2015); and Kunsthalle Wien, Vienna (2014). Her work was included in La Biennale de Montréal (2016), curated by Philippe Pirotte, and the Gwangju Biennale (2016), curated by Maria Lind. Belerique was long-listed for the 2017 Sobey Art Award and has completed residencies at Walk & Talk (The Azores, Portugal) and Fogo Island Arts (Fogo Island, Newfoundland), among others. In July 2022 she will open a solo exhibition at Fogo Island Arts, curated by Nicolaus Schafhausen. She lives and works in Warkworth, Canada.

Tom Engels works as a curator, editor, writer, educator, and dramaturge at the intersection of performance and the visual arts. Since October 2021, he has been the Artistic Director of Grazer Kunstverein. He was Associate Curator for "trust and confusion" (2021) at Tai Kwun Contemporary, Hong Kong, in collaboration with Xue Tan and Raimundas Malašauskas, and served as the editor of voices, trust & confusion's online audio program. He is the initiator of "front" (2021), Brussels, where he has presented artists including Trevor Yeung, Julie Peeters and Elena Narbutaitė, and Hamish Pearch. Other recent curatorial projects include "Touch Release", Nassauischer Kunstverein, Wiesbaden (2021); Techno-Intimacies in collaboration with Joanna Zielińska, M HKA, Antwerp (2021); "Hana Miletić: RAD/Materials", Haus, Vienna (2020); "another name, spoken", Jan Mot, Brussels (2017); and the series "Matters of Performance" at

the Royal Academy of Fine Arts (KASK), Ghent (2017–2019). He is the co-editor of *Conversations in Vermont: Steve Paxton* (2020), published by Sarma, for which he received a Robert Rauschenberg Foundation Archive Research Grant. He has collaborated with choreographers such as Alexandra Bachzetsis during "documenta 14", Athens and Kassel, and Mette Ingvartsen for "steirischer herbst", Graz, as well as with Mette Edvardsen, Bryana Fritz, and PRICE/Mathias Ringgenberg. Since 2013, Engels has held a visiting professorship at The Royal Academy of Fine Arts (KASK), Ghent, and has regularly contributed to various art educational contexts such as P.A.R.T.S. (Brussels), a.pass (Brussels), S.N.D.O. (Amsterdam), and Centre National de la Danse (Paris). His writing has appeared in magazines including *Artforum International, frieze, Spike Art Magazine, CURA., Extra Extra Nouveau Magazine Erotique,* and *De Witte Raaf.*

Ruba Katrib is Curator and Director of Curatorial Affairs at MoMA PS1, New York. At PS1 she has curated exhibitions such as "Greater New York" (2021), "Niki de Saint Phalle: Structures for Life" (2021), Simone Fattal's retrospective in 2019, and solo shows for Edgar Heap of Birds (2019), Karrabing Collective (2019), Fernando Palma Rodríguez, and Julia Phillips (2018). From 2012 to 2018 she was the Curator at Sculpture Center in New York where she organized over twenty exhibitions including "74 million million million tons" (2018) (co-organized with artist Lawrence Abu Hamdan) and solo shows of the work of Carissa Rodriguez, Kelly Akashi, Sam Anderson, Teresa Burga, Nicola L., Charlotte Prodger, Rochelle Goldberg, Aki Sasamoto, Cosima von Bonin, Anthea Hamilton, Araya Rasdjarmrearnsook, Magali Reus, Gabriel Sierra, Erika Verzutti, David Douard, and Jumana Manna. In 2018, Katrib co-curated SITE Santa Fe's biennial, "Casa Tomada", along with José Luis Blondet and Candice Hopkins.

Nicolaus
Schafhausen

is a curator, director, author, and editor of numerous publications on contemporary art. Since 2011 he has been the Strategic Director of Fogo Island Arts, Canada, an initiative of Shorefast, a charitable foundation dedicated to finding alternative solutions for the revitalization of areas prone to emigration.

Among other projects, Schafhausen, together with the editor-in-chief of The New Institute in Hamburg, Georg Diez, is presently conceiving the exhibition, "symposium," and conversation series "Speculations - Survival in the 21st century" for the Hamburg Deichtorhallen (2023–2024). Schafhausen was the Artistic Director of "Tell me about yesterday tomorrow" (2019–2021), an exhibition at the Munich Documentation Center for the History of National Socialism about the future of the past. He has curated numerous international exhibitions such as "Mediacity Seoul 2010", the Dutch Pavilion at the Shanghai World Expo 2010, and the 55th October Salon "Disappearing Things" in Belgrade (2014). He was the curator of the German Pavilion for the 52nd (2007) and 53rd Venice Biennale (2009), and curator of the Kosovo Pavilion for the 56th Venice Biennale (2015). Schafhausen also cocurated the 6th Moscow Biennale in 2015.

In addition to curating exhibitions and other projects, Schafhausen has led institutions such as the Frankfurter Kunstverein, Künstlerhaus Stuttgart, Kunsthalle Wien, and Witte de With Center for Contemporary Art in Rotterdam. He was Founding Director of the European Kunsthalle, conceived as a project to examine the conditions and structures of contemporary art institutions independent of local government mandates.

Claire Shea

is the Director at Fogo Island Arts. From 2017 to 2021, Shea was the Deputy Director at Para Site, Hong Kong's leading contemporary art center and one of the oldest and most active independent art institutions in Asia. While at Para Site, she curated the major group exhibition "An Opera for Animals", 2019 (with Cosmin Costinas, which toured to Rockbund Art Museum, Shanghai,

in summer 2019). She was an Associate Curator for the 8th Shenzhen Sculpture Biennial, "We Have Never Participated" (2014) at OCT Contemporary Art Terminal, Shenzhen (curated by Marko Daniel, with Dr. Wenny Teo and Lu Pei-yi). Shea was previously Curatorial Director at Cass Sculpture Foundation in Goodwood, England, (2008–2016), where she curated "A Beautiful Disorder" (with Dr. Wenny Teo and Ella Liao Wei), an exhibition which featured new commissions by contemporary artists from Greater China including Cheng Ran, Cui Jie, Li Jinghu, Wang Wei, and Xu Zhen (Madeln Company). She was a member of Bold Tendencies' selection and steering committee in London, England (2010–15); curated the inaugural Thun Ceramic Residency in Bolzano, Italy (2015); and worked at the Peggy Guggenheim Collection in Venice, Italy (2006–2008).

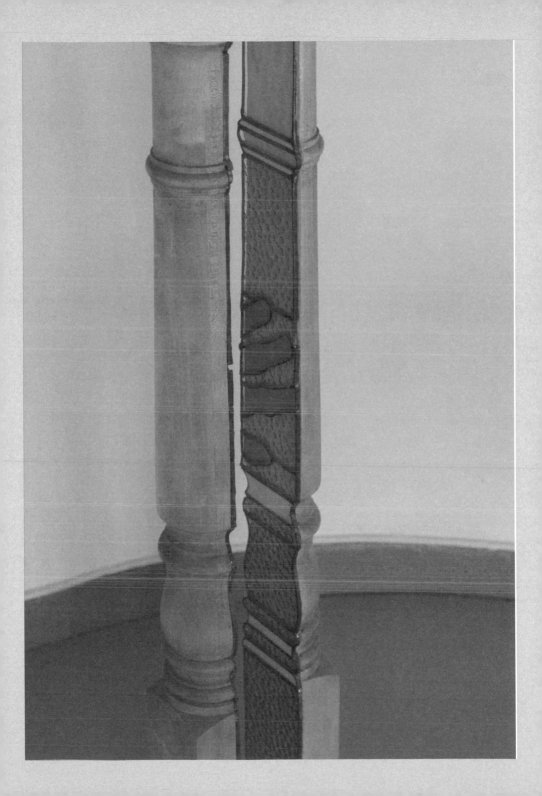

Fogo Island Arts (FIA) is a contemporary arts and ideas organization on Fogo Island, located in Newfoundland & Labrador, on traditional Mi'kmaw territory and the ancestral homeland of the Beothuk.

Founded in 2008 as an artists' residency program, Fogo Island Arts was created with the conviction that art and artists have the capacity to instigate social change and offer new perspectives on issues of contemporary concern. By facilitating collaborations and connections between a local and international network of practitioners and thinkers, Fogo Island Arts aims to provide relevant insights on questions of human relationships with place, nature, financial capital, and one another.

Fogo Island Arts' residency program has grown into a full program of exhibitions, public programs, publications, and focused research programs including the Fogo Island Dialogues and Summer Workshops, all of which aim to bridge connections between local and wider global communities.

Fogo Island Arts is a charitable program of Shorefast, a registered Canadian charity with the mission to build economic and cultural resilience on Fogo Island, making it possible for local communities to thrive in the global economy.

Fogo Island Arts graciously acknowledges its Patrons for their essential support of residencies, programs, and exhibitions.

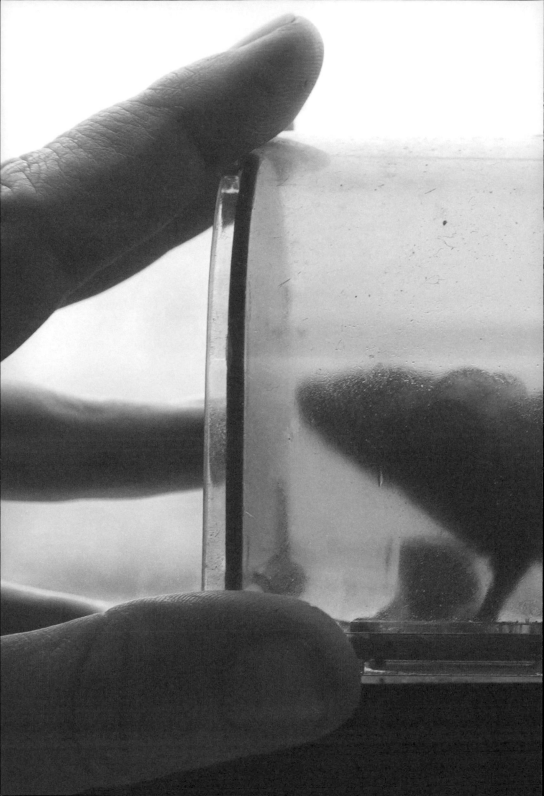

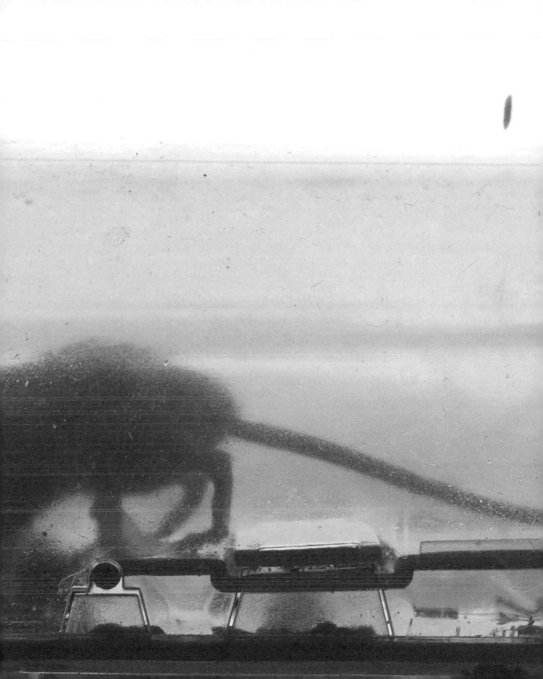

Nadia Belerique—Body in Trouble

This catalogue is published on the occasion of the exhibition Nadia Belerique—"Body in Trouble", Fogo Island Gallery, July 29 to September 25, 2022.

Co–published by Fogo Island Arts and Sternberg Press

Editors: Claire Shea and Nicolaus Schafhausen
Managing Editor: Iris Stunzi
Copyediting and proofreading: Shanti Maharaj and Anna Roos
Graphic design: Studio Markus Weisbeck
Printing and binding: Gutenberg Beuys Feindruckerei GmbH, Langenhagen

ISBN 978-1-915609-10-6

Distributed by the MIT Press, Art Data, Les presses du réel, and Idea Books

Photo credits:
© Courtesy of the artist and Joshua Jensen

Acknowledgements:

Nadia Belerique would like to thank Tony Romano, Isola Belerique Romano, Danielle Greer, Daniel Faria, Madeleine Taurins, Matthew Hyland, Sojourner Truth Parsons, Nele Kaczmarek, Jule Hillgärtner, and everyone at Kunstverein Braunschweig, Nicolaus Schafhausen, Claire Shea and Ronan, Iris Stunzi, Micaela Dixon, Joshua Jensen, Grace O'Boyle, Marc-Olivier Brouillette, and Tom Engels and Ruba Katrib for their thoughtful contributions to this publication.

Fogo Island Arts
Highway 334 – Suite 100
Fogo Island, NL A0G 2X0
www.fogoislandarts.ca

Sternberg Press
71–75 Shelton Street
London WC2H 9JQ
United Kingdom
www.sternberg-press.com

shorefast

FOGO ISLAND ARTS

49° 37' N, 54° 12' W